The Speech

U. F. Shah

Wimberley Press

Copyright © 2017 U.F. Shah

The Author has asserted her right under the Copyright, Designs and
Patents Act, 1988, to be identified as Author of this Work.
All rights reserved. No parts of this publication may be reproduced
in whole or part, or stored in or introduced into a retrieval system,
or transmitted, in any form, or by any means (electronic,
mechanical, photocopying, scanning, recording or otherwise)
without the prior permission of the Author or Publisher.

ISBN-10: 1999759702
ISBN-13: 978-1999759704

www.ufshah.com

This book is dedicated to the hearts that found me.
The hearts that loved me. The hearts that believed in me.

Without you I would have been *lost*
never *loved* and never *found*.

The words from *my heart* reach *your fingertips* through the pages of *this book*.

CONTENTS

1 *Lost* 6

2 *Loved* 104

3 *Found* 142

LOST

*Chaos within
is the worst kind.*

The Organ's Speech

No.

She did not ask for it when the animal in you
saw her body as your midnight feast.

Such a shame that your brain was never tamed.

Never taught that she doesn't welcome the chains
of your desires.

No.

She
did
not
ask
for
it.

Oh *'man'*

the womb that carried you
was inside a *Woman*.

The breast that fed you
was on the body of a *Woman*.

The hands that raised you
belonged to a *Woman*.

Yet you so proudly mock the
worth of a *Woman*.

The Organ's Speech

At the tender age of ten
he silenced his cries
despite his lungs screaming inside.

He allowed his body to be chained to the floor
by this devil dressed in human skin.

He was overcome with weakness
and so he lay still
with the words echoing in his ears

Boy's
Don't
Cry.

Yes
it's the ones closest to us
that have a tendency
to hurt us the most.

The Organ's Speech

Tired of fighting away this feeling.
The weight of sadness is too heavy a burden.
I appear *normal* but the diagnosis is real.

Tired of carving out messages onto my wrists.
Messages no one ever reads.

The *voices* in my head tell me to trust them.
They reassure me that they know the secret
to making the pain end
and I'm beginning to believe
that they're my only friends.

There's a rope
hanging from the ceiling.

They're telling me
to tie it around my neck.

Freedom is calling.

At least that's what
they said.

- Depression

And when they ask

what happened?

Despite every stomach turn
every thud inside my chest
every knot in the back of my throat

I look at them
and say

nothing.

The Organ's Speech

How could I have not seen
the pain that was wrapped up
in your speech.

- *Silent Victim*

They shun the *skin* that *clothes* me.

- Racists

The Organ's Speech

I began wishing I was clothed in lighter skin.
Skin that wouldn't draw attention to my ethnic roots.
Skin that wouldn't call for them to look.
Skin that didn't scream
I am not one of you.

But then I watched them tan
tan their light skin into darker shades.

And I became confused as to why
my *soft*
brown
sunkissed skin
was perceived as ugly
whilst
their pale
sunburnt skin
was the definition of beauty.

- Brown Girl

They plant seeds of hate
and still expect love to grow.

The Organ's Speech

Your freedom of speech
freed your tongue
and imprisoned me.

- *Double standards*

My hands

they want to tell stories
of the broken pieces of my heart
they've been made to hold.

The Organ's Speech

They taught me that it is shameful
to make reference to a swollen belly.

A swollen belly that carries life.

A swollen belly that once
carried *them*.

- *Cultural norms*

Tired
of
fighting
battles
alone.

The Organ's Speech

Patience is what defines you.

You learned the art way before you were taught it.
But *they* made patience become a burden.
Almost an ache.

Under the label of patience
they stole from you
your *right* to defend yourself
your *right* to scream when you were hurting.

They made you suppress all the emotions
you've wanted to spill for years.

Because to them
patience means to endure
to endure *without making a sound.*

Walls
are a dangerous thing.

The Organ's Speech

Walls.
They hold secrets so well.
Prison walls.
Hospital walls.

Bedroom walls.

Sometimes

I lose myself
inside myself.

- *Anxiety*

The Organ's Speech

They say
stay strong
even when everything's falling apart.

But what do you do
when trying to stay strong
is the reason you're falling apart?

Break the silence
before the silence breaks you.

- Abuse

The Organ's Speech

They told you that you were made of the strong stuff.
The type to never break down.

You then convinced yourself that you were invincible.
Dealing with all trials and tribulations with courage.

Through every hardship you fought away the tears
and forced still the quivering lip.

But after years of resilience
you realised that this façade of strength
was in fact nothing other than denial.

In reality
you were every bit as broken
as the ones that made you believe
in this kind of strength.

You realised that those appearing to be pain free
are usually the ones that are the most broken.

It never goes away.

It just finds a place
somewhere in the hollows of your chest.

And when you least expect it
when you think it's over
it re-emerges
dragging you back to that *one* moment
you've prayed that you could forget.

- Grief

The Organ's Speech

It still beats
even when it's broken.

It's in the silence of the night that
my thoughts are the loudest.

The Organ's Speech

I understood pain at the age of five
whilst looking into my mother's eyes
as she sat on the stairs past midnight
waiting for my father to come home.

My father never understood *absence*
even though he was the reason *I* understood.

The Organ's Speech

It seems as though
we're moving further away
from where we need to be.

I find myself losing myself a little.

The closer I get to you
the further I distance from myself.

The Organ's Speech

She craved freedom.

A desire to be as free as the waves within the sea.

But even the waves are bound by the shore
teaching her that freedom is never to be
entirely *free*.

He was used to the silence of the walls.

And me?

I was all too familiar
with their screams.

The Organ's Speech

The loss is not *your* fault.
Forgive yourself.

- *Miscarriage*

My love overflows
a little more than
I'd like it to.

My pain cuts deep
and a little sharper
than I can bear.

My heart aches
a little more than
I thought it would.

And you?

You loved me
a little less
than I hoped you would.

The Organ's Speech

He chokes me
with the same hands
that he runs through my hair.

- Domestic Violence

I fought to be your happiness
even though you insisted
on taking away mine.

The Organ's Speech

You didn't think.
Just jumped right in
with your eyes closed.
Allowed yourself to be led
by the one you trusted more than
that heart inside of you.

That heart inside of you
whose beat you chose to ignore.
A beat carrying every truth your
ears had failed to hear.

And you loved him
loved him beyond belief.
Promising him parts of you
no one had ever seen.
Parts no one had ever experienced.

You gave him
the most prized possession of them all.

You gave him
your *soul*.

U.F. Shah

Sometimes it's our dreams
that awaken our worst nightmares.

The Organ's Speech

Perhaps you say
but do not feel
and perhaps you feel
but you do not say.

I thought I knew loneliness
before I met you.

But you showed me
the true meaning of loneliness.

To be in someone's arms
and still feel *empty*.

The Organ's Speech

Was is it not enough
that I poured my soul
into you?

U.F. Shah

It gets tiring
giving love
but never receiving any.

The Organ's Speech

I will never understand
how his words could
feed the hunger in me
yet starve me
at the same time.

The sound of knocking haunts me.

Two a.m. and you crawl into bed.
The smell of her perfume fresh on your neck
and the thirst for her on your lips.

The Organ's Speech

Every night
you would pour me a drink of your lies
and I would sip on it
one poisonous
mouthful
at a time.

You caught him out.
Discovering that his words
were everything you wished
they hadn't been-
empty.

The Organ's Speech

You didn't know how to swim
yet you dived into this relationship.
Not thinking about whether
you'd be able to hold yourself
above the waters.

And this man
he would never save you
from drowning.

In fact
he would be the one
holding your head down
in the oceans of his madness.
Not allowing you to come up for air.

Not
even
once.

It was your place to heal me.

Yet it was *you*
who had broken me.

The Organ's Speech

I have nothing left to say to you.

The very words I wish I was strong enough to say.

They told me love meant
that I should meet him in the middle.
And that sometimes the middle may not be enough
so I may need to meet him on his end.

They told me love meant
that I should support him
through all the times he decides to run.
And that I should patiently wait for his return.

They told me love meant
taking the abuse when he was distressed.
And that I should bury *my pain* inside.

They told me love meant
silence
and that I should never speak up against him.

They taught me *love*
in the same way that they had been taught –
nothing but *self sacrifice* dressed in love's clothes.

- The women birthed by our culture.

The Organ's Speech

When they have opened you up
like a ripe fruit
they devour your juices
and then spit you out
like the seed.

U.F. Shah

She dressed herself in your insecurities
wore a half-hearted smile
crafted by the poison of your kisses
and choked on your broken promises.

The Organ's Speech

If only men felt the need
to uphold their promises
as much as they do their pride.

She kept making excuses to stay.
Referring to her kids or her family
sometimes even considering the community.
But we all knew these weren't her reasons for staying.

Instead it was her emotional attachment to him.
Her belief that she would self destruct without him.
That *he* was the reason for her being.
Despite the fact that *he* was the one
killing a part of her with every passing day.

Sometimes we wished she could see her self worth.
Wished that we could convince her
that she didn't need him.

But that's the thing about a destructive kind of love.

You witness the destruction
but you convince yourself
that there are so many reasons for you to stay.

The Organ's Speech

You never knew how to beg
until you were forced to.
Forced to beg him to stay.

Your integrity told you to be stronger.
To be wiser.
To not beg a man who was not worthy of you.

But you had convinced yourself
that you'd never find love if you walked away.

So you allowed your heart to take over.

You allowed your heart to take over
and it made you forget
that you can never *force* love.

And so here you were
trying to persuade a man into loving you
even though you knew
he never would.

You
are
worth
the
destruction.

The Organ's Speech

The truth is
that he couldn't even commit
to ending a *conversation.*

And so you were left with unfinished stories
requiring you to sleep
in order to dream up an ending
to help ease the pain.

She'd talk about walls
as though I was the one who
crawled inside of her and built them.
Failing to see the strength that I had to build
to fight them.

She'd hurl abuse at me every day
yet *I* was the one titled the *abuser*.

She would battle for the title of strength
telling me all that she's had to endure being a woman
and I would sit and listen.

Sometimes I wish I could
lay my heart out in front of her
so she could see

that *my heart*
was just as
soft as hers.

The Organ's Speech

He was fighting to be the man
he didn't know how to be.

- The Fatherless Son

They failed to wrap me in their love
even though *I* was the one who
blanketed them with mine.

The Organ's Speech

He blinded you with all the lies.

He made you believe
all the things that were never true.
He made you believe you were worth *nothing*.

He built a home made from sand in your heart
knowing that it would never last.

And so it was never you.
It was never *you* who wasn't worthy.

I still find myself foolishly searching through crowds
in the hope that seeing you
will ease the longing from my eyes
and the pain of your absence from my mind.

The Organ's Speech

I wish we'd spent long enough
talking about safety.

About how to save one another
when we were falling.

I wish you'd told me
the places to look for you
when I felt that I was losing you.

I would have searched for you there.

I have travelled far and wide
in an attempt to forget you.

Yet I've only ever managed
to carry my love for you
to every corner of this earth.

The Organ's Speech

I clutch onto your memory so tightly.
Afraid that if I loosen my grip
I'll lose all that I have left of you.

U.F. Shah

As the autumn leaves turn to spring blossom
I still think of you.

The Organ's Speech

I've wanted so much to tell you
of the moments that made me smile.

The moments that made me laugh hysterically
and even the moments that I've cried.

I've wanted to tell you
about how the traffic was crazy on the way to work.
How that place we used to dine at
doesn't serve our usual anymore.
To tell you that I streamed the final season
of our favourite series and the ending was
nothing like we'd thought.

I've wanted to tell you
that *I miss you.*

But I'm afraid that you've felt
nothing at all.

I searched for your reflection in him.

Searched for that look in his eyes
that lived in yours.

I endlessly searched his entire being
to find a piece that resembled you.

But he couldn't be *you.*
No matter how much I tried
to find you in him.

He was *nothing*
in comparison to you.

The Organ's Speech

Regret
is a sign
of having invested
too much.

I was the sunrise at Mount Fiji
in the Land of the Rising Sun.

Yet you were busy sleeping.

The Organ's Speech

I burned in your flame
and now all that's left
are
ashes.

My stomach kicks me
every time
you are mentioned
in the past tense.

- 17 Dec 1975 – 18 Feb 2017

The Organ's Speech

It pains me
that the only memory of you that's left
is the one of you leaving.

We keep picking at our wounds
while expecting them to heal.

The Organ's Speech

My mind was hating you
but my heart was loving you.

I was torn between the two.

I thought I was ready to embrace the idea of love.
Pictured us laying under blue skies soaking the sun
and dark nights observing the stars.
Resting my head on your chest
whilst we talked through our deepest of thoughts.

Yes.
I thought I was ready to embrace the idea of love.

But somewhere between your idea and mine
I realised that the love never existed at all.

The Organ's Speech

Perhaps your search among appearances
for what only appears in the heart
is the reason you find yourself broken.

Yes

I ran.

I ran at every opportunity.
I ran as my heart was breaking
and sometimes
even before anyone had the chance to break it.

I just wish he was brave enough to stop me.
To stop me from running.
Brave enough to fight my demons.
Brave enough to tell me that he loves me enough
to never leave.

Then maybe.

Just maybe.
I could stop
long enough
to stay.

The Organ's Speech

He told me

*when you're tired of running
I'll be here
waiting.*

I only wish that
this
would have been
enough.

You knew the feelings were gone
but you insisted on making it work.

Perhaps you should have been true to yourself
and accepted that you no longer found comfort
in the heart you once called *home*.

The Organ's Speech

Half hearted attempts from you
filled our relationship.

You never did respond to my questions.
And yet I would forgive you
even in the absence of an apology.

Over and over you would hurt me
with your bad habits that you dressed up as *mistakes*.
Because you knew mistakes could be forgiven
and bad habits not so much.

And even though my word was everything
I'd overlook the loyalty you had towards yours.

I would let it go.

Because it was you.
Only because it was *you*.

Why is it that now I am free from your shackles
there is nothing more that I want
than to be imprisoned again?

The Organ's Speech

I scream your name as though
it's the only language in me that remains.

You're afraid to admit
that you're feeling the emptiness without him.

You keep telling yourself
that strength is defined by your very backbone.

How then
could a *man*
make you feel weak?

The Organ's Speech

Years gone by
yet this date on your calendar
sinks your heart a little.
And you wonder if he still remembers
all the things you're unable to forget.

- 14 May 2007

I went from being whole to broken.
Loving you to losing you
but never hating.

Soon days turned into weeks
and weeks into months.
Now

it's been years.

The Organ's Speech

If I had known the taste of heartache
I would have never placed your name
on my tongue.

There was always a place for you in my heart.
Never did I shut you out.

But still you left.

I thought long and hard through the tears
and the sleepless nights.

I thought I could train my mind to forget.

Only I self-destructed
in all my attempts to forget you.

The Organ's Speech

I guess *Time* was the only thing
that was of service to her.

It forced her to be stronger.

Despite her resistance
Time took away her rights over him.

The right to miss him
the right to be mad at him
and most importantly the right to love him.

It's as though *Time* had formed the ability to speak
the ability to speak and say

Let go now
It's Time.

Holding on
is much more painful
than letting go.

When you let go
you accept that it's over.

Whilst holding on
is just you living in the memory
of someone that left
so long ago.

The Organ's Speech

Your sorrow lies in *almost*.

He *almost* stayed.
He *almost* settled down.
He *almost* loved you.

But you *almost* stayed with a man
who didn't know how to love you.

You *almost* settled for a man
unworthy of your beauty
your ambition
and your strength.

You *almost* sacrificed *yourself*
by falling in love with him.

So in fact
the very nature of *almost*
is what saved you from a lifetime of hell.

I'm no longer angry at you
nor am I hurting.

I'm not in love with you anymore.

But why is it that every time we talk
I unintentionally make it seem as
though I'm still not over you.

- Conversations with the ex

The Organ's Speech

I sit here
whilst you stare into my eyes.

I think about the time when I loved you
but you didn't feel the same.

Back then it was me who would stare
into your eyes searching for the love
I so desperately wanted to find
but never did.

And today
I sit here
avoiding eye contact
afraid you'll see the truth.
Afraid that this time around
I would be the one hurting *you*.

If he misses you
after breaking your heart
ask yourself
is he missing you because he loves you
or is he just feeling lonely?

The Organ's Speech

You had insisted on searching
for that which
you were holding
in the palms of your hands.

So I set you free.

He can tell you how
everything changed
when you left.

He can make you
believe he was broken.

But the moment
you let him back in
he's going to remind you
of all the reasons
you let go
in the first place.

The Organ's Speech

I asked that he refrain from making me promises.

He asked me *why?*

I explained how promises aroused an expectation.

So what's the harm in that? He asked.

The harm? I said.

I guess he'd never had to
cradle pieces of his broken heart
nor had he experienced the pain
birthed by unmet expectations.

How untouched he was
by the sufferings of a broken soul.

I have buried you so deep
into the pits of my past.

So why now
do you insist
that I take
a spade to my mind
and resurrect you?

LOVED

*Have you ever been somewhere
where your heart screamed out to you
begging you to stay?*

The Organ's Speech

When I surrender to hardships
I remind myself of true sacrifice
by comparing myself to you.

When I fall weak at my knees
I find strength in you.

When my heart can no longer carry
the burden of my sins
I seek comfort in you.

And when no dictionary can provide me
with the definition of love

I look to you
as the man
and woman
that *defined* love.

- Ami Abu

The thing about love is
it makes you fall for the beauty of the rose
paying little attention to the stem full of thorns.

It feeds your desire for something real
and something pure.

So you allow your eyes to become
the veil over the devil's door.

The thing about love is
it's intoxicating
not to mention a destructive force.

The truth about love is
I'm too afraid to let it seep
into the pores of my unkissed soul.

The Organ's Speech

Tell me you see me
through the barriers
they've created between us.

Tell me you'll love me
enough to break them.

Search for me in places
no one else would find me.

The Organ's Speech

Do not come to me
with your eyes wide open.

Instead

come to me
so as to convince me
that *I* was the one
your *heart* chose.

Fall in love with those that touch
not the *body*
but the *soul*.

The Organ's Speech

Find someone who wants to carry you
like the waves in a river
yearning to carry the reflection
of the trees which beside they flow.

To be admired by the onlookers
for such a beautiful union of the two.

It was the first time I laid eyes on her.
She bowed her head down slightly
and glanced up at me
with a smile on her face
bright enough to light the skies.

And it was that *one look*
that *one smile*
that made me realise

She
was the one I'd been waiting for
my entire life.

Dear Future Spouse

I promise I'll find my way to you
but first promise me this.

Promise me that you and me
we'll be a beautiful piece of art
in the gallery we'll call our home.

Promise me you'll let me find
all the secret places in which you hide
so that I can hide in there with you.

Promise me that when you're lost
you'll allow me to hold your hand
without being afraid of losing me.

Promise me when you feel as though
something's missing
you'll accept pieces of me
to fill the emptiness you feel.

Promise me you'll let me steal your pride and ego
and put it in a place where it'll never be used.

Promise me you'll let me teach you how to love
and you'll let me learn from you too.

I promise
I'll give you my all
my flaws included.

I'll give you my honesty
loyalty and love.

As I'm certain in loving you
I'll find a place
where I'll be loved too.

The Organ's Speech

We will make love our world.

And we will fill love's sky with our magic.

Rain down so hard
leaving behind floods of comfort.

Hold hands and pick fruit from the trees of truth
and let the juices of honesty drip from our lips.

We will speak a language of passion
and sing songs of lust
laying in gardens of trust.

You
in my arms
in our world
of love.

She was oblivious
to all the things that made her beautiful.
And that's what I loved about her the most.
From her big brown eyes
to her contagious smile.

She
was the definition
of beauty.

The Organ's Speech

Let me peel away the layers
of insecurities that cover you.

Let me reach the place where
you left comfort so long ago.

Let me remind you
of the beauty that you are.

U.F. Shah

And it is in your beauty
that I find solace.

The Organ's Speech

He was beautiful.
Beautiful from the roots.
Standing six foot tall before me.

He wore a smile.
A familiar kind.
And he spoke
with words which felt as though
they had made their way down
from the heavens
while gently placing themselves
onto the tip of his tongue.

His eyes.
They were the gateway
to all things great.
Truth.
Humbleness
and sincerity.

Here they were before me
Principles
in their human form.

He held me
in the heat of his palms
and melted me.

The Organ's Speech

There are very few people in this world
that will leave imprints on your heart.

We in ourselves are language.

Basic with some.
Intermediate with some.
Advanced with others.

The Organ's Speech

I allow the winds to whisper to me
words of wisdom
for they have travelled to lands
that I only dream of visiting.

And He so effortlessly
eases the pain
of my broken heart.

The Organ's Speech

Find someone
who gives more.

Not just to you
but to the world.

U.F. Shah

Love was my sickness
and he was my cure.

The Organ's Speech

You loved him not only because
he was the epitome of beauty.

Instead you loved him
for the way he noticed all the things
that really mattered.

It wasn't just the way he complimented your smile
and the beauty of your eyes.

Instead it was much more than that.
It was much deeper than that.

You loved him for the way in which
the sincerity of his soul complimented yours.

And you knew *love*
wouldn't get any
purer than that.

U.F. Shah

He took me to places
I'd never seen before.

Yet every step felt as though
I'd finally made it home.

The Organ's Speech

And here we are
you and me
in the midst of
a beautiful storm.

U.F. Shah

You imprinted your love on her in braille
so even the blind man would know.

The Organ's Speech

I wake up everyday
with your love
running through my veins.

U.F. Shah

Your mere presence
has awakened
my organ of love.

The Organ's Speech

I leave my mind
free to wander
and still
it leads only to you.

Take me in my rawest form
and purify me with your love.

The Organ's Speech

My heart insists
and yearns
for a moment
spent kissing
the depths
of her soul.

And everything I had lost
I found
in you.

The Organ's Speech

In your eyes
is where I found hope.

In your smile
is where I found love.

By your side
is where I found strength.

And within your soul
is where I found me.

You
awaken
parts of me
that
I
never
knew
existed.

The Organ's Speech

And every crease
of my aged skin
will tell a story
of you and me.

I shall not compare you to roses
nor shall I compare you to the stars
nor the moon
nor the oceans.

I shall not compare you.
For you *my love* are that
to which nothing compares.

FOUND

*Do not let the world
harden your heart.*

The Organ's Speech

Love yourself so fiercely
that no one dares to love you
half- heartedly.

U.F. Shah

When you permit the world to dress you
it will dress you with flaws.

The Organ's Speech

Stop
breaking yourself into pieces
to make yourself fit.

If they don't appreciate a drop of you
they certainly won't appreciate
the depths of your oceans.

Don't empty your soul for anyone.

The Organ's Speech

Closed minds are a prison.

Break
free.

When I have a daughter

I will teach her that she
does not need to
think like a man.

The Organ's Speech

Use your ability to heal.

Heal others.
Heal them physically.
Heal them emotionally.
Heal them mentally.

And perhaps begin with yourself.
Heal yourself.

Be *you*
in a world
where everyone
is trying to be
someone else.

The Organ's Speech

If a seed of hate has been planted
be sure to never water it.

U.F. Shah

Sleep is an unwelcome guest
when you're busy chasing your dreams.

The Organ's Speech

Perhaps we are searching
for that which already lies within us
yet we are just too blind to see.

U.F. Shah

The sweetest of dreams
are the ones
we see with our eyes
wide open.

The Organ's Speech

Stop expecting him to
define your worth.

Only *you* define
your worth.

People dictate our lives
more than we think.

Break the chains.

The Organ's Speech

Does it trouble you
that I found happiness
in the palms of *my* hands
and not yours?

U.F. Shah

You were never too fragile.

Instead you were *too strong*
for a man too weak
to remain loyal.

The Organ's Speech

Pain carried in the heart
is reflected in the eyes
yet seen only by those
brave enough to
unearth your soul.

U.F. Shah

Sometimes
admitting that you feel pain
doesn't make you weak.

It simply makes you
human.

The Organ's Speech

I am not afraid to follow my heart.

- *Daily Mantra*

U.F. Shah

If my heart
does not feel something
when you are in my presence
my mind can kick and scream as much as it likes
I will not listen to my mind over my heart.

The Organ's Speech

Do not allow a relationship
not worthy of being called love
to define you.

Know when love is
hurting you.

Know when love is
breaking you.

Know when love has
changed its meaning
in order to reassure you.

Love is not meant to
destroy you.

It is supposed to be
the platform for your growth.

One day
they too will experience life
whilst crawling on their knees.

In that moment
the pain they once ridiculed
will feel far too real.

And they'll wish
they had been there for you
instead of leaving.

The Organ's Speech

He wanted to run.
And She?

She wanted to fly.

In loving you
I lost myself
and in leaving you
I found myself.

The Organ's Speech

Remember why you left.

- When the past comes knocking.

I thought I needed you
to love me in all the places
I'd never been loved before.

Only to realise that these were the places
I
had never loved
myself before.

The Organ's Speech

I have more
than you could
ever give me.

She
was a revolution
waiting to happen.

The Organ's Speech

I am not like the flower.
I *am* the flower.
My scent will attract you like a swarm of bees.

I am not like the sunset.
I *am* the sunset.
I will have you in awe of my beauty.

I am not like fire.
I *am* fire.
I will burn you if you mishandle me.

I am not like a man.
I am a woman.
I am everything a man could never be.

There is an ocean of strength
running inside of me
yet you judge me
having only witnessed the streams.

The Organ's Speech

She holds secrets
that would break spines
yet she carries them so well.

There's a roar inside
that I cannot silence.

There's a roar inside
that I *will not* silence.

The Organ's Speech

They laugh when you are suffering.
They laugh when you are growing
and they laugh when you succeed.

The beauty of laughter becomes
their tool of mockery.

Yet the echoes of their laughter
are nothing but *empty*.

- Ignorant people

My heart is my weakness
and I cannot fight against it.

For how could I succeed against an organ
that doesn't falter to control my existence
despite being caged between my ribs.

Forgiveness is an act of kindness
a sign of a soft heart
and the strength
of a wise person.

- Keep your heart clean.

U.F. Shah

Always be kind
for you never know
which act of yours
will lead someone
to question theirs.

The Organ's Speech

Despite the world's attempt to unveil me
He conceals my flaws
and for that
I am grateful.

You spent years searching for the one who
would understand the state of your soul.

Pacing the earth's surface in an attempt
to find the missing piece to make you feel whole.

But with every step of your search
you were only distanced from the
travellers of this world.

Perhaps this was a sign for you
that you should only seek comfort
from the *One* who put life into your soul.

The Organ's Speech

If He created intellect in *them*
then why not in *you*?

If He created strength in *them*
then why not in *you*?

If He created Kings and Queens out of *them*
then why wouldn't He of *you*?

God created *you*
just as He created *them*.

- Never doubt yourself

Never tame the warrior within
to please the cowards.

The cowards believe
the world isn't a place
for the brave.

The warriors
prove that it *is*.

When you finally reach the pinnacles you had only ever dreamed of reaching. Do not forget the hands that became your stairwell to success. The hands that laid themselves out for you. The hands that carried your weight.

Thank You

I could not have done this without you.

Made in the USA
Lexington, KY
16 July 2018